D0845612

GERHARD RICHTER *Florence*

GERHARD RICHTER

Florence

Hatje Cantz Publishers

Florence 1999/2000

Oil on photograph

12 x 12 cm each

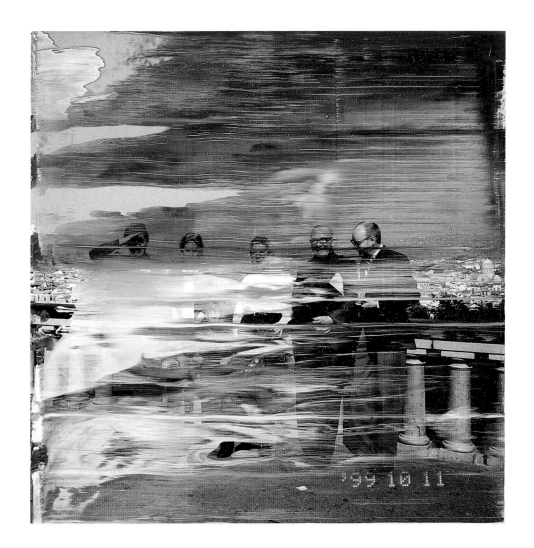

23. 11. 1999

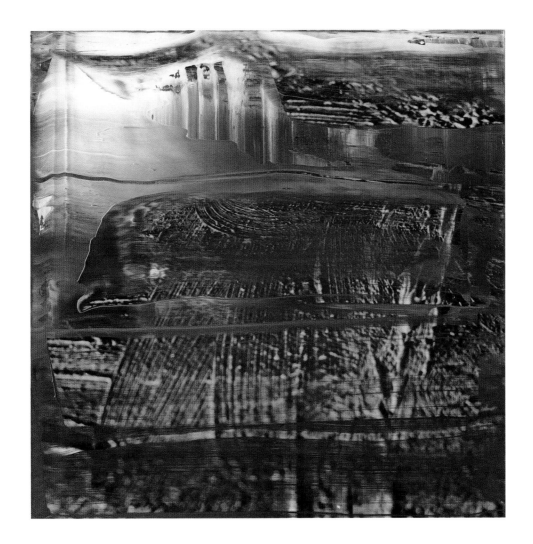

28. 11. 1999

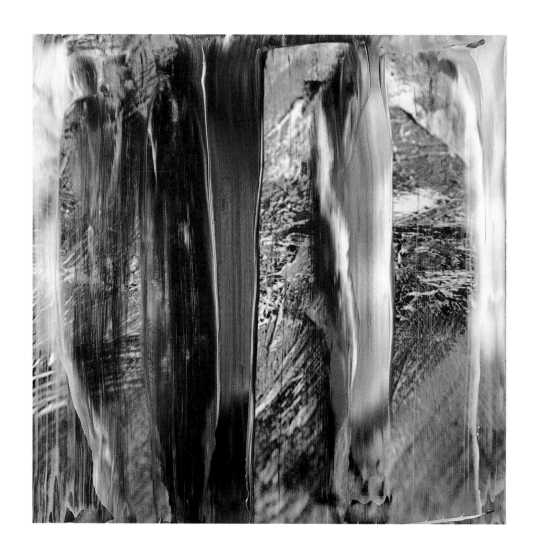

29. 11. 1999

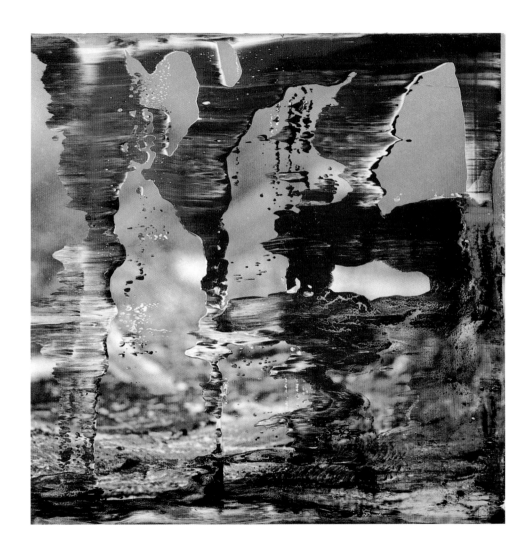

30. 11. 1999

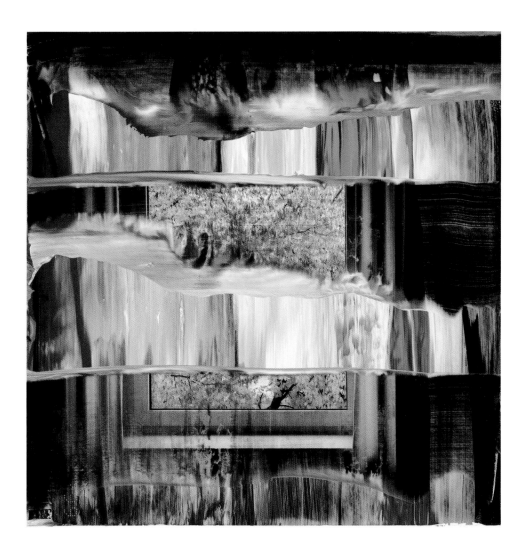

1. 12. 1999

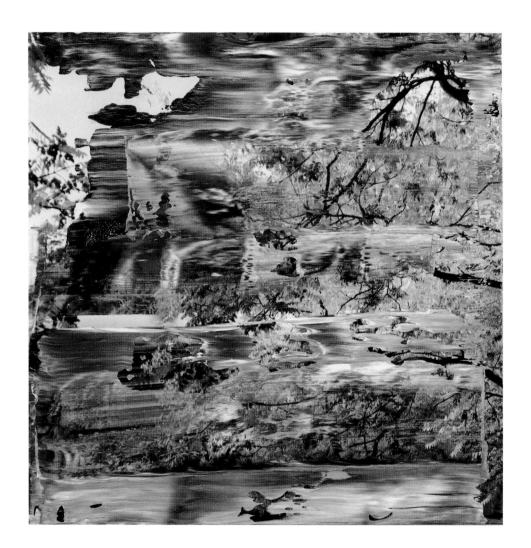

2. 12. 1999

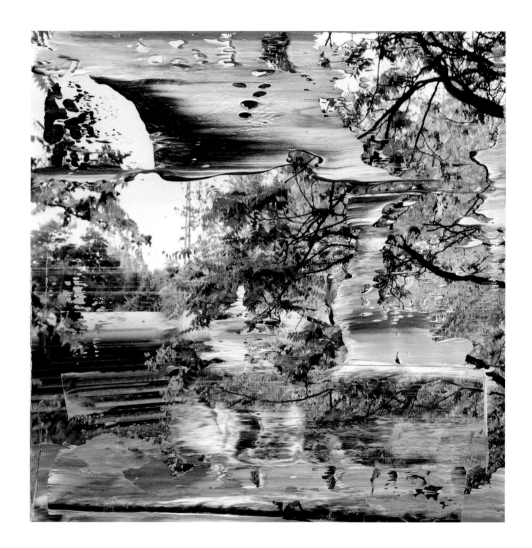

3. 12. 1999

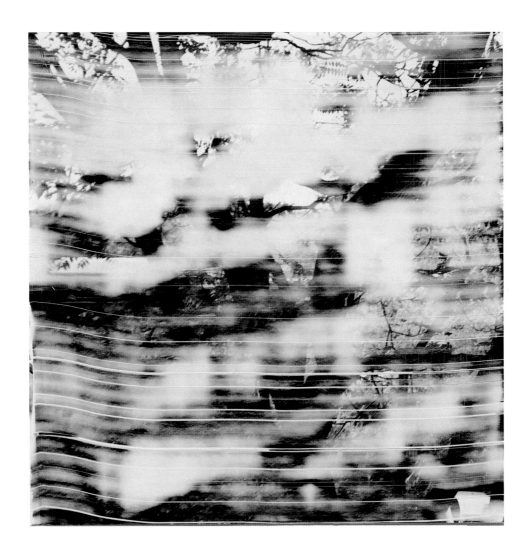

5. 12. 1999

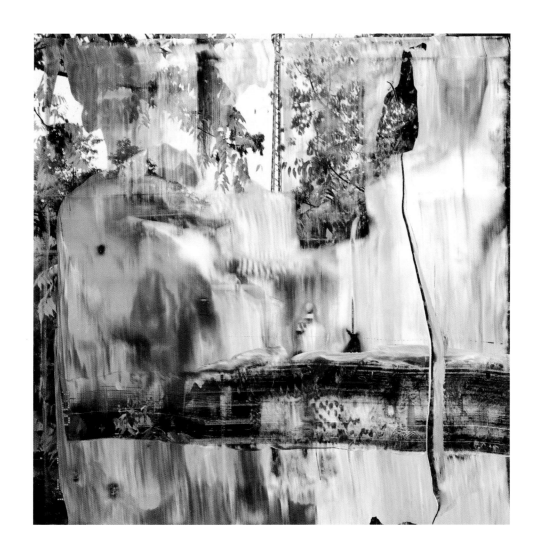

6. 12. 1999

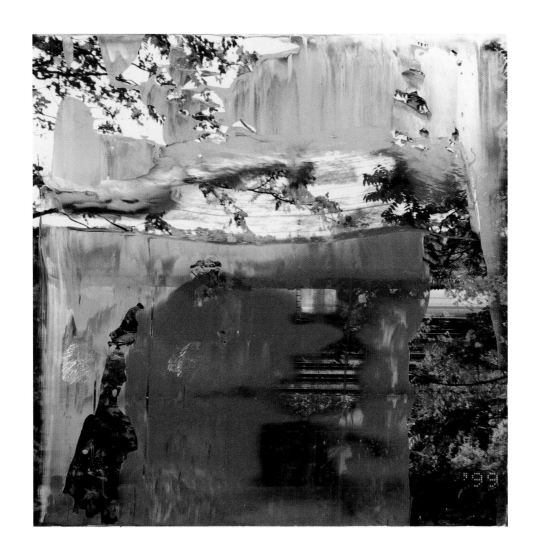

7. 12. 1999

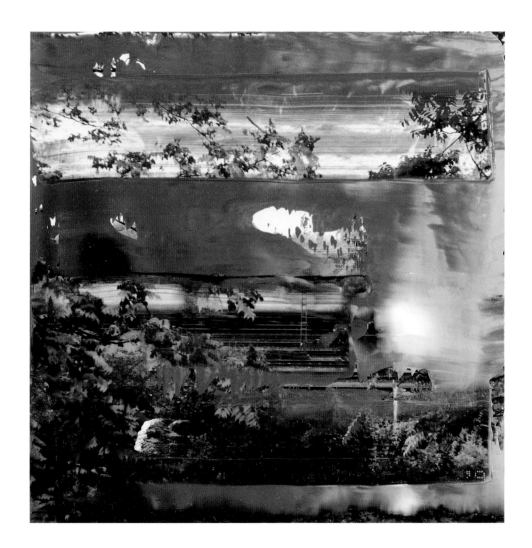

8. 12. 1999

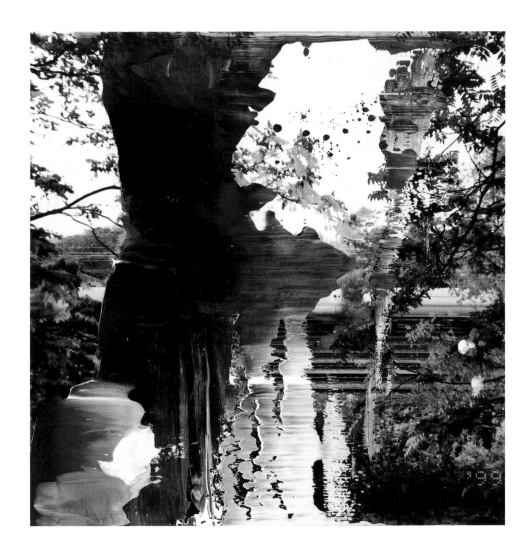

9. 12. 1999

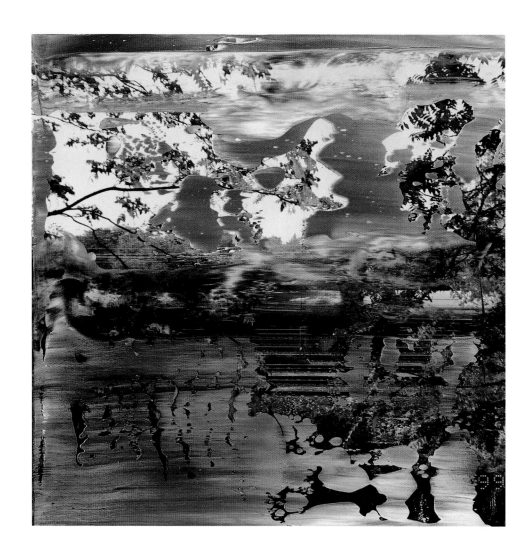

10. 12. 1999

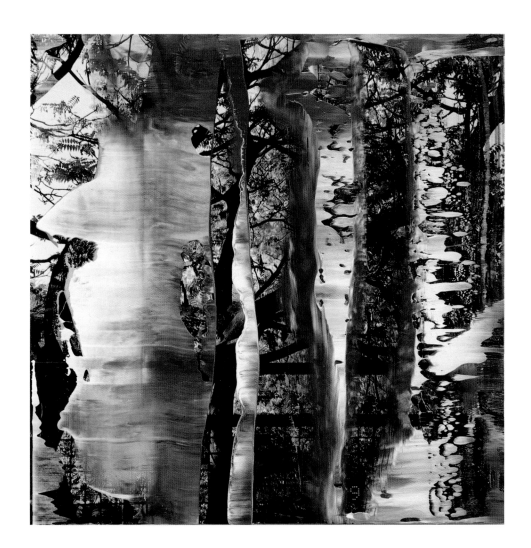

12. 12. 1999

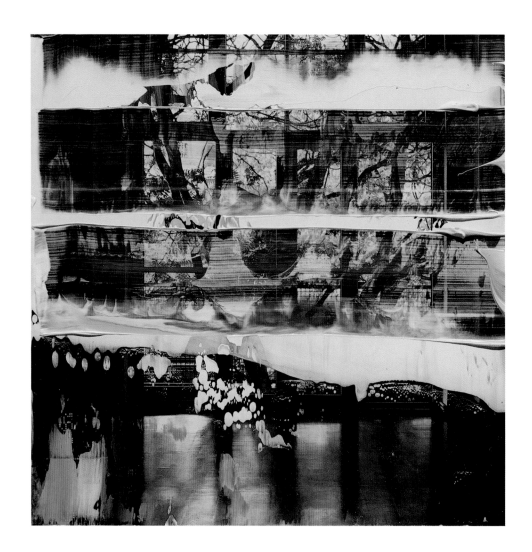

13. 12. 1999

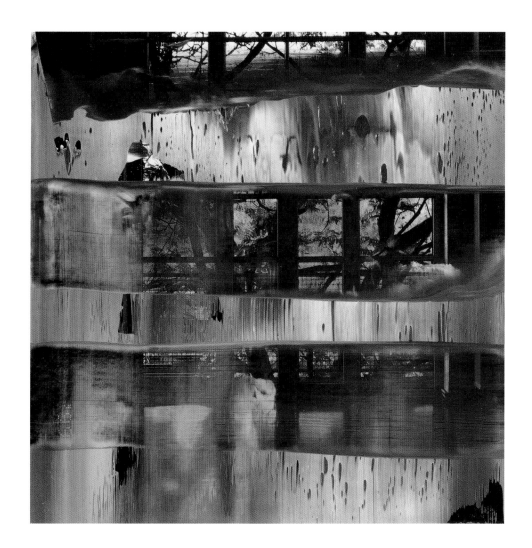

14. 12. 1999

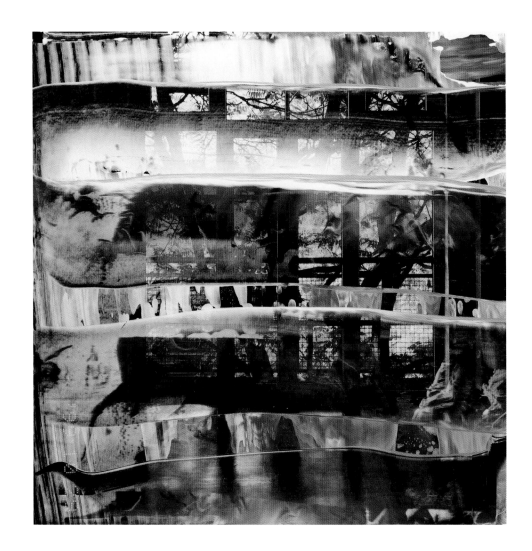

15. 12. 1999

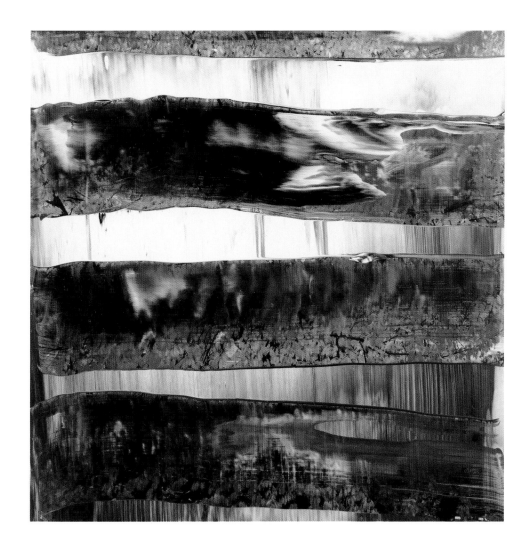

16. 12. 1999

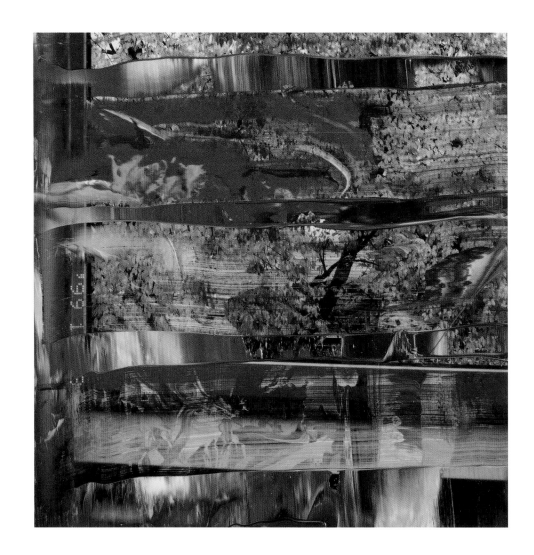

17. 12. 1999

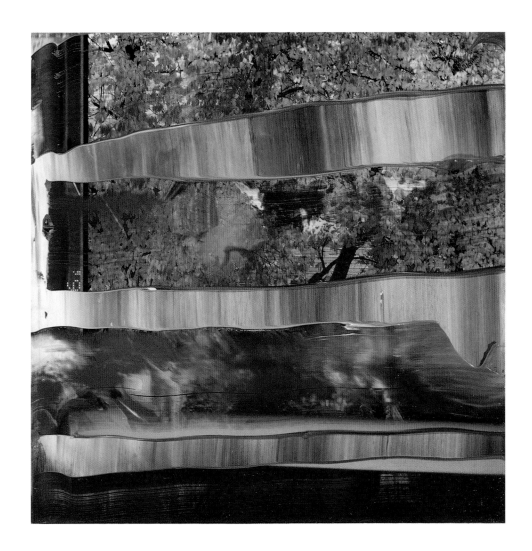

18. 12. 1999

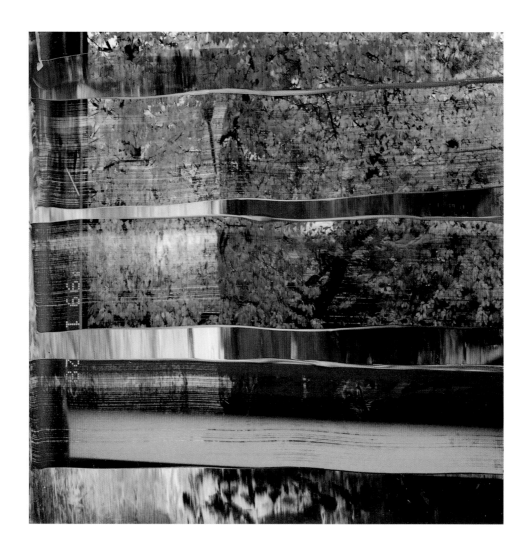

19. 12. 1999

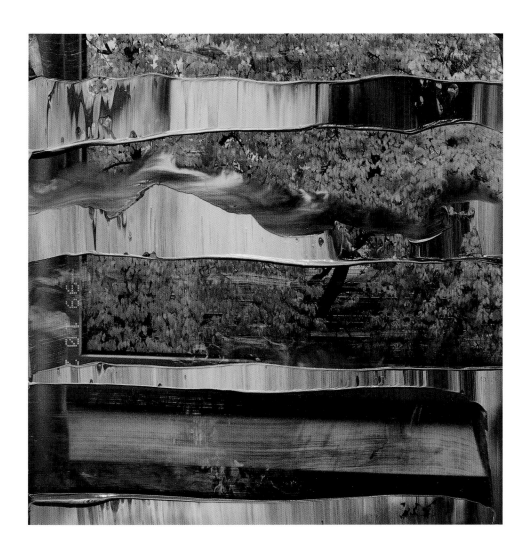

20. 12. 1999

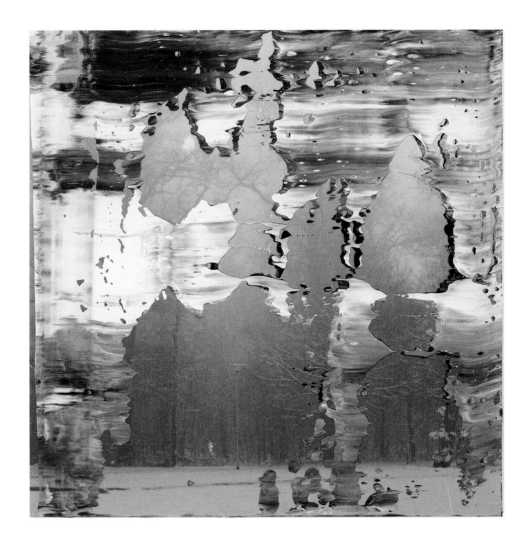

21. 12. 1999

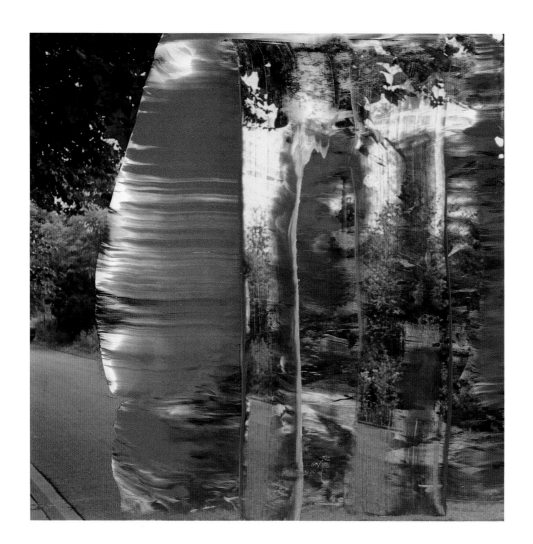

23. 12. 1999

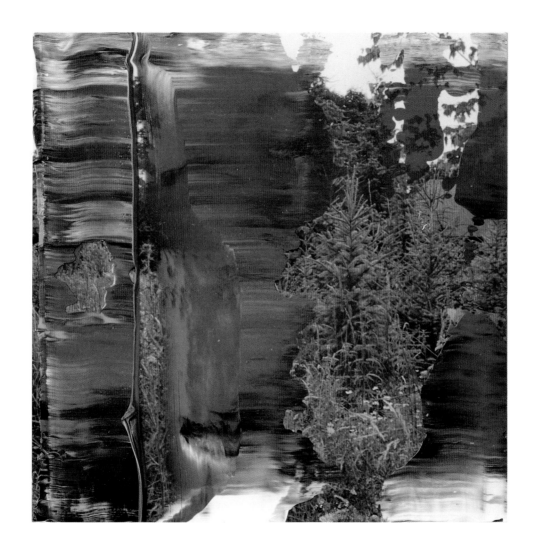

24. 12. 1999

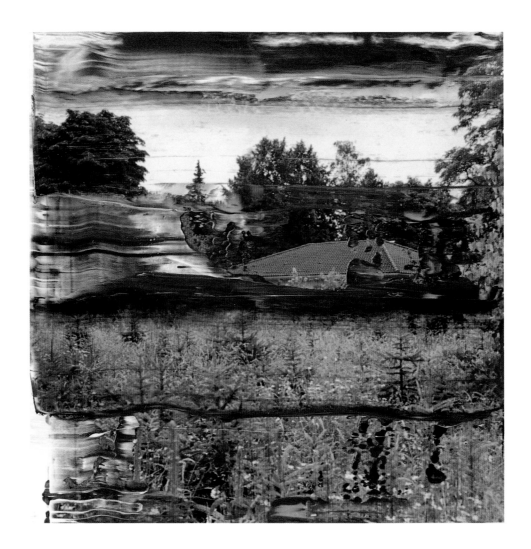

25. 12. 1999

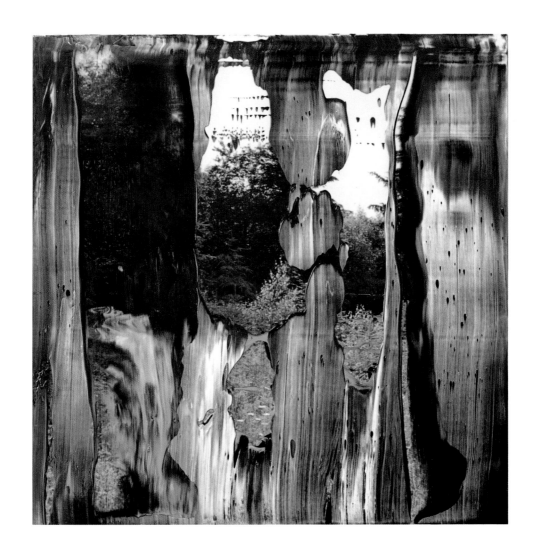

26. 12. 1999

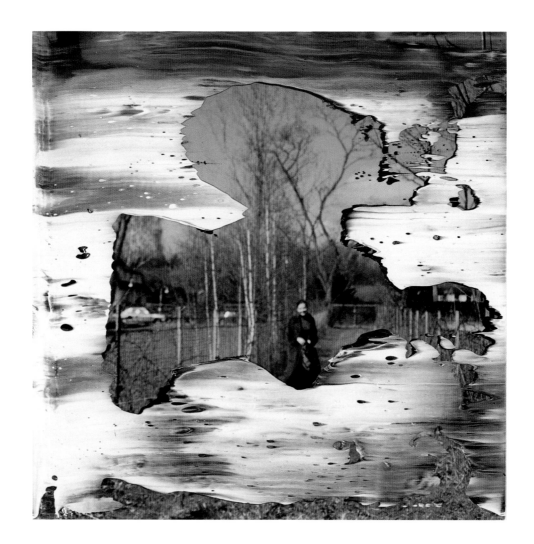

27. 12. 1999

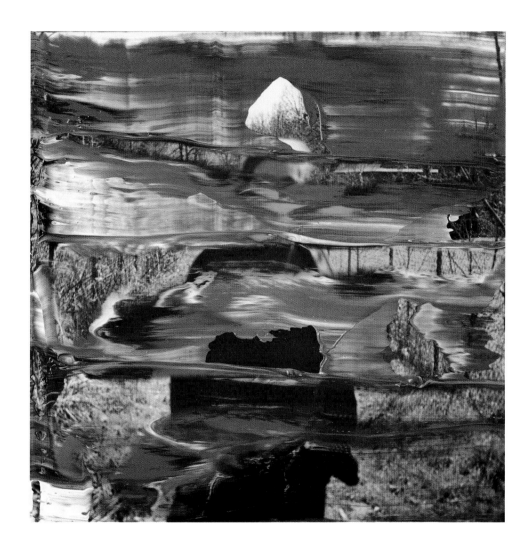

28. 12. 1999

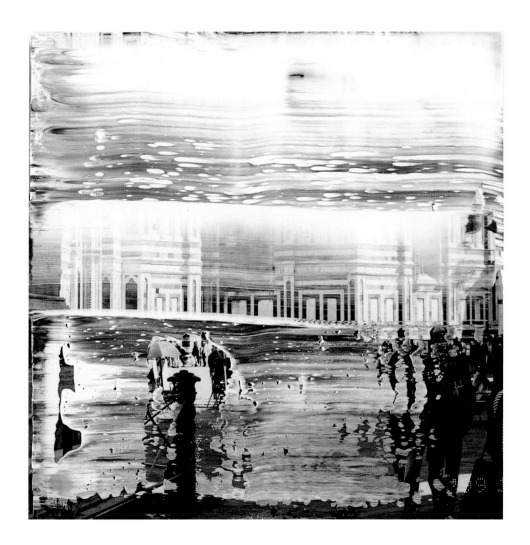

1. 1. 2000

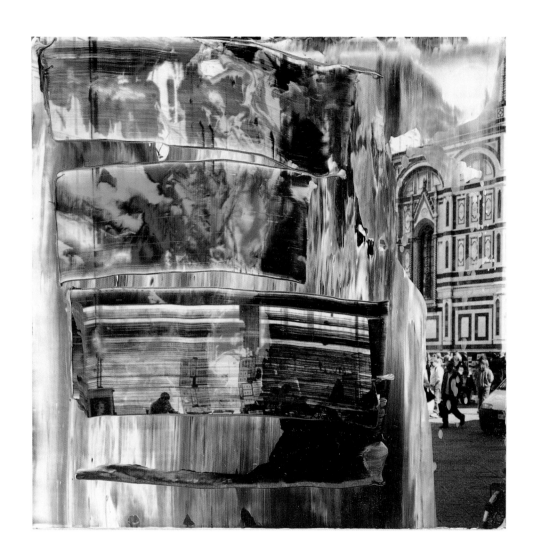

2. 1. 2000

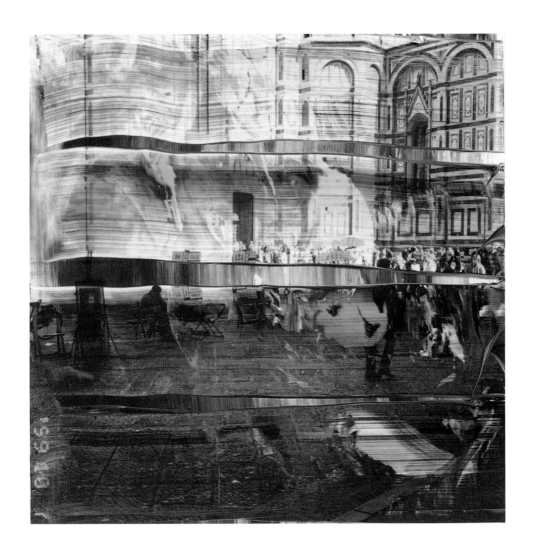

3. 1. 2000

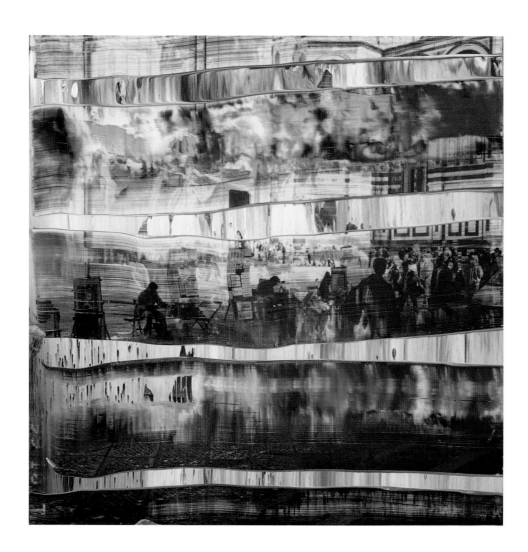

4. 1. 2000

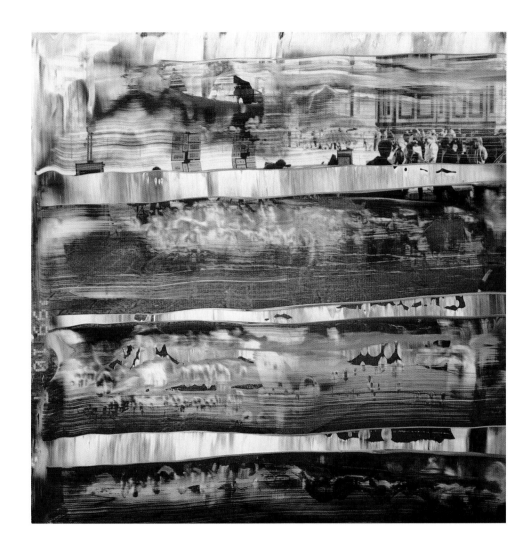

5. 1. 2000

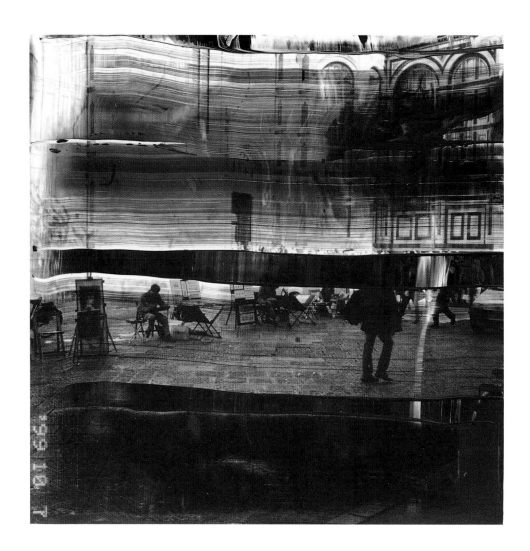

6. 1. 2000

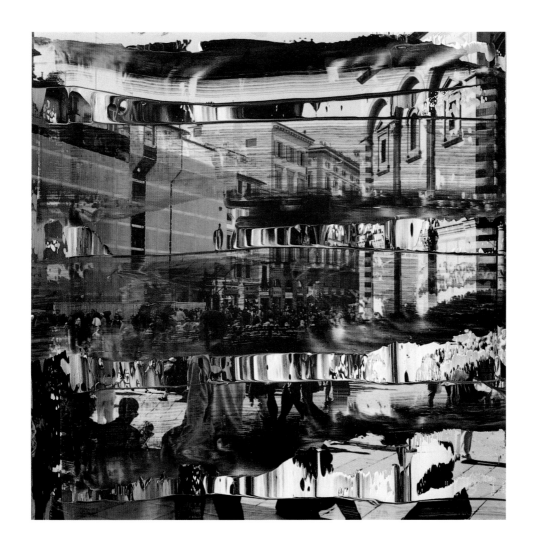

7. 1. 2000

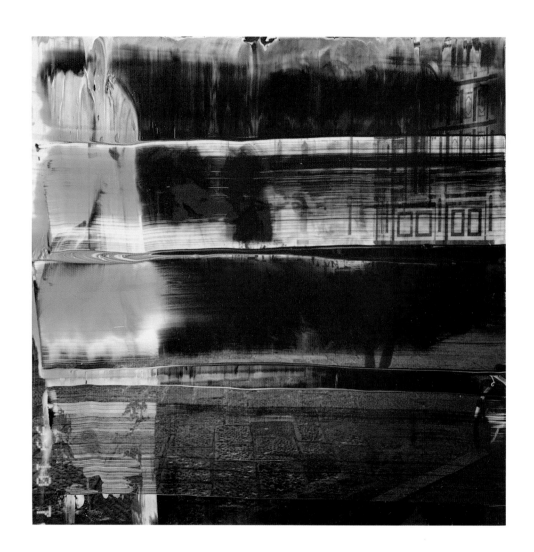

8. 1. 2000

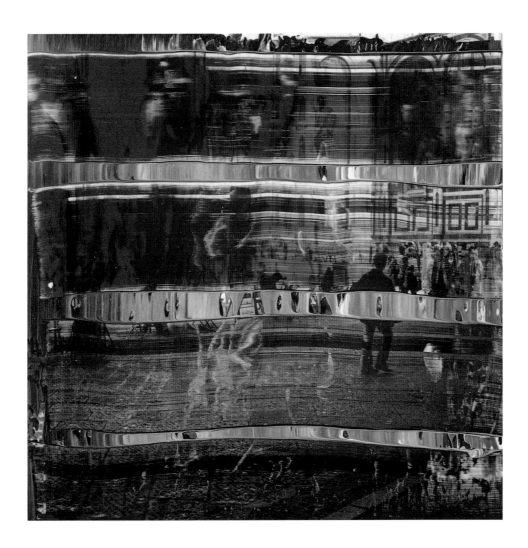

9. 1. 2000

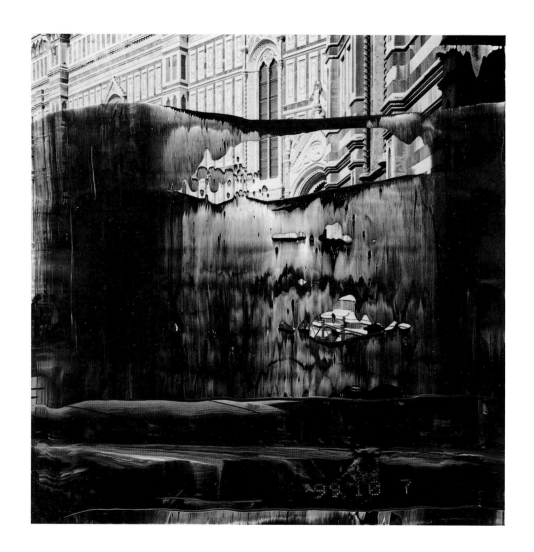

10. 1. 2000

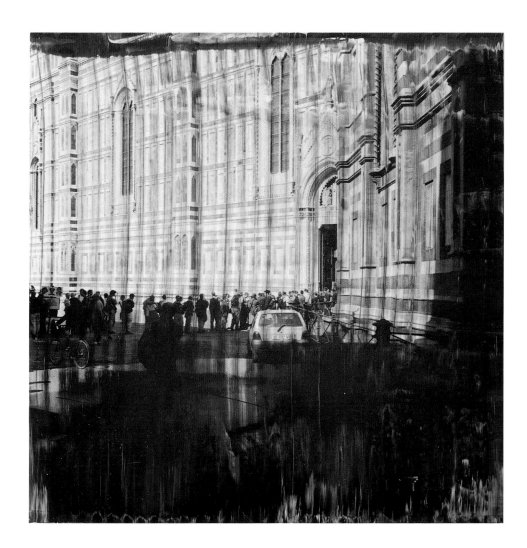

11. 1. 2000

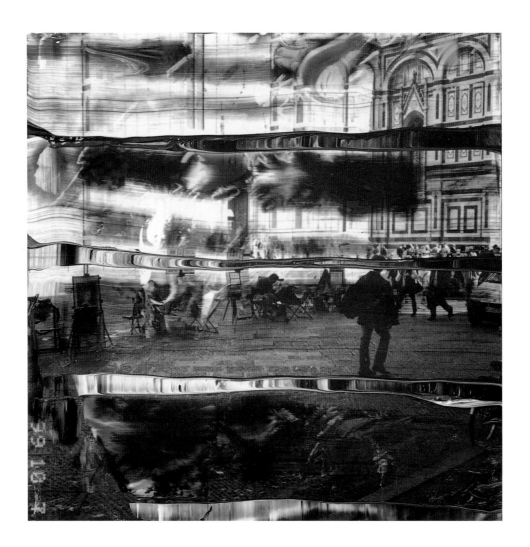

12. 1. 2000

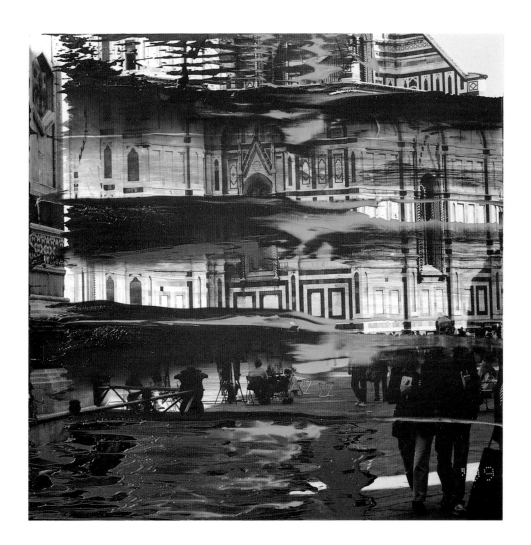

13. 1. 2000

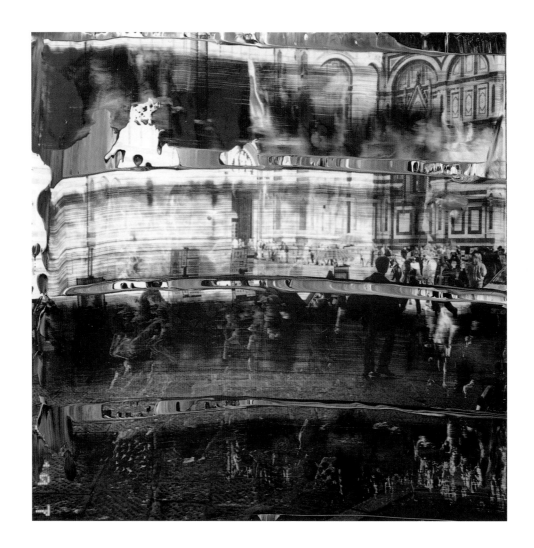

14. 1. 2000

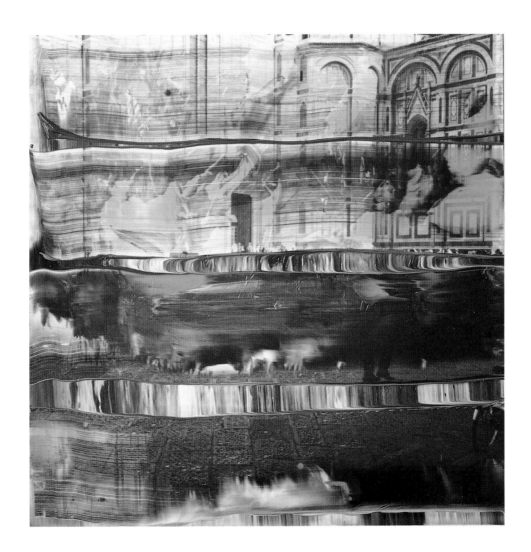

15. 1. 2000

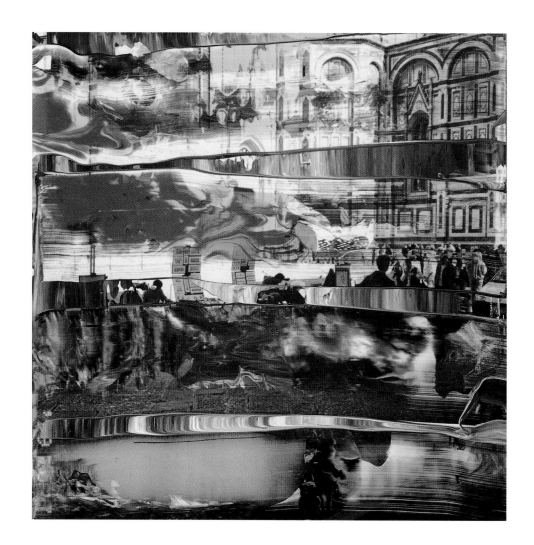

16. 1. 2000

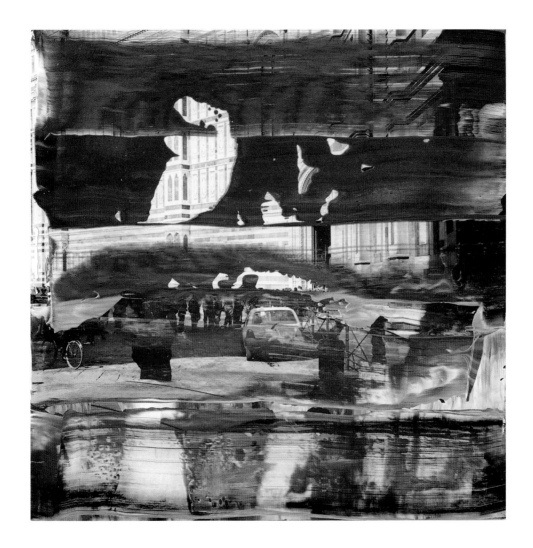

17. 1. 2000

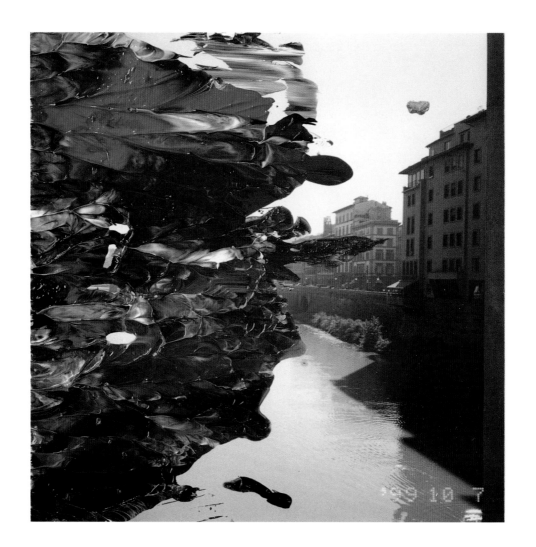

18. 1. 2000

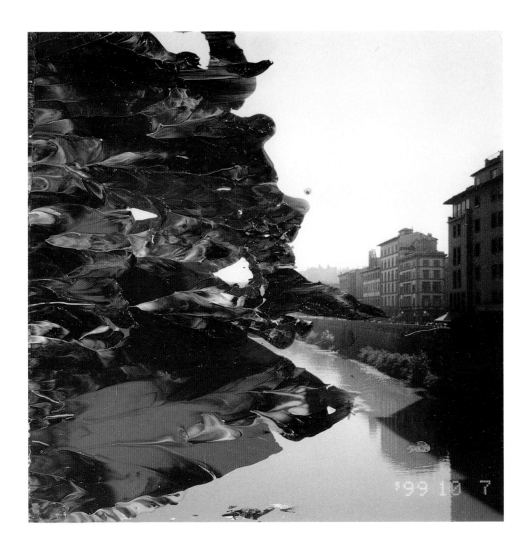

19. 1. 2000

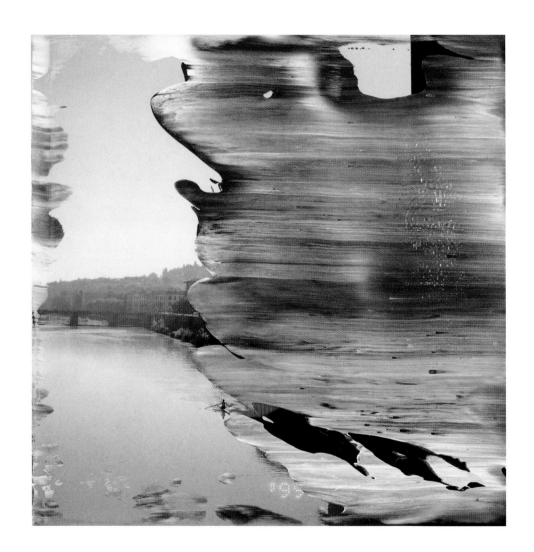

21. 1. 2000

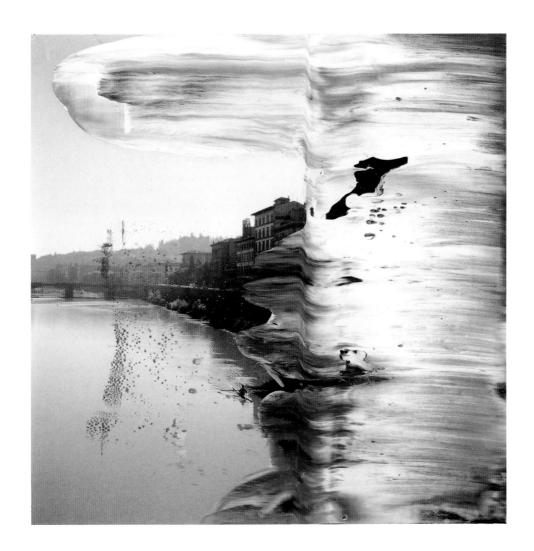

22. 1. 2000

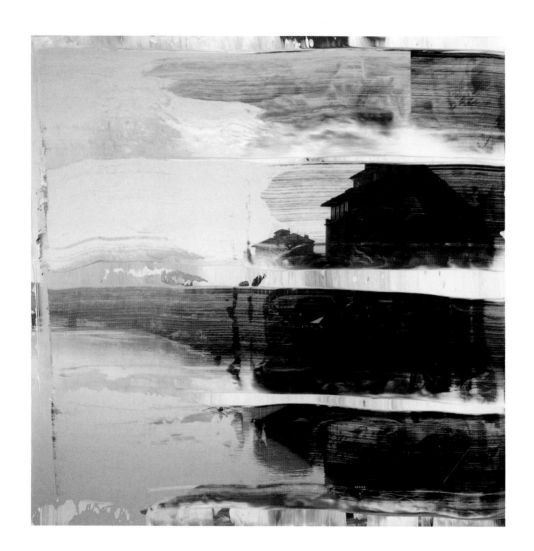

23. 1. 2000

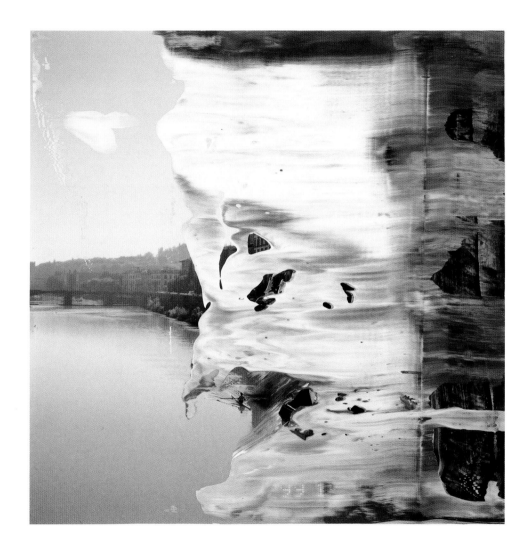

24. 1. 2000

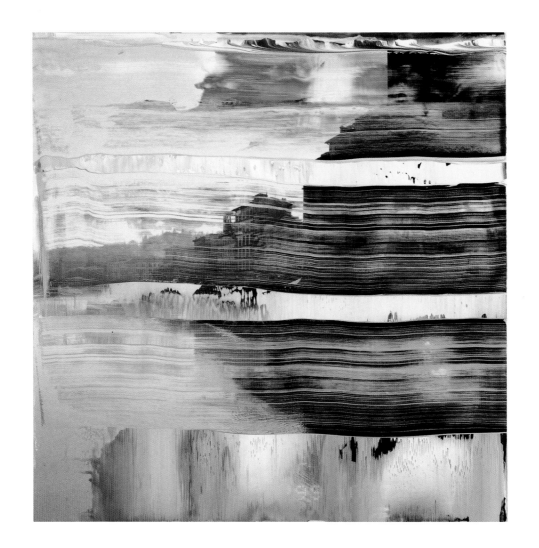

25. 1. 2000

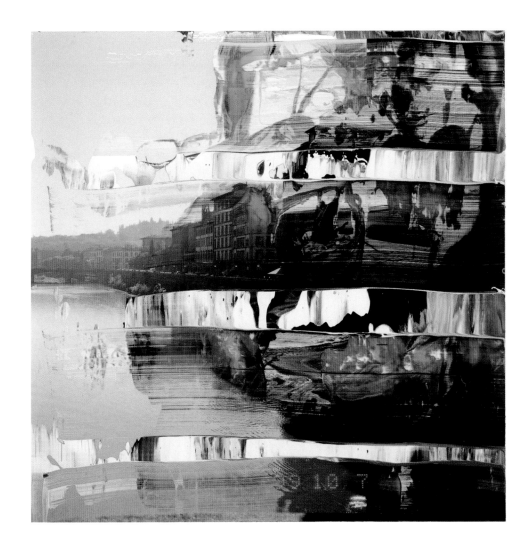

26. 1. 2000

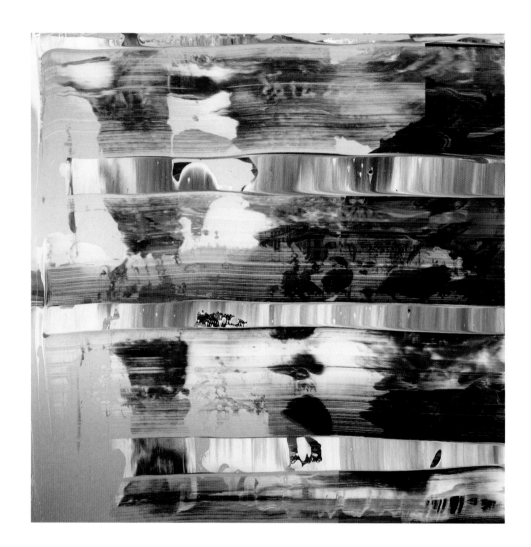

27. 1. 2000

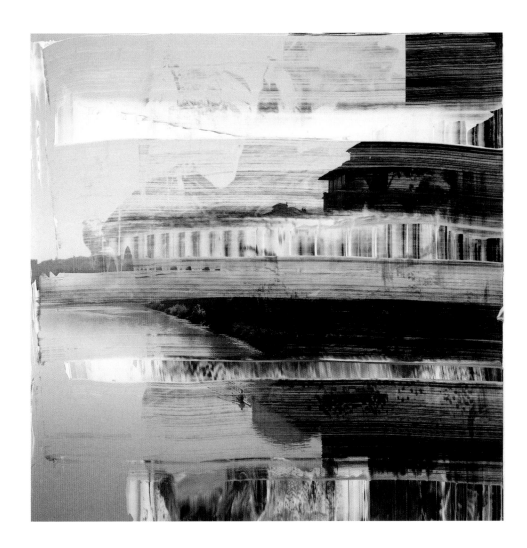

28. 1. 2000

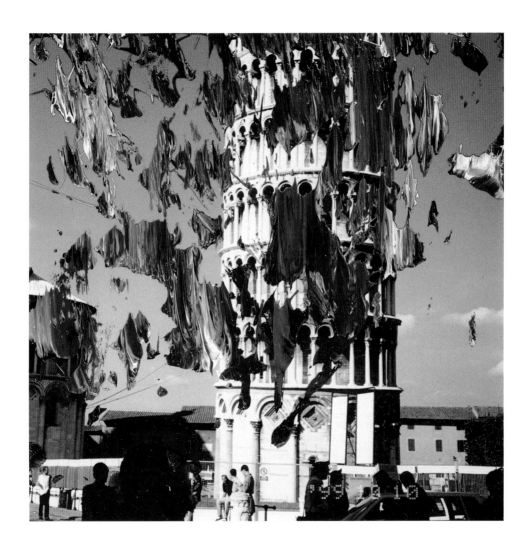

29. 1. 2000

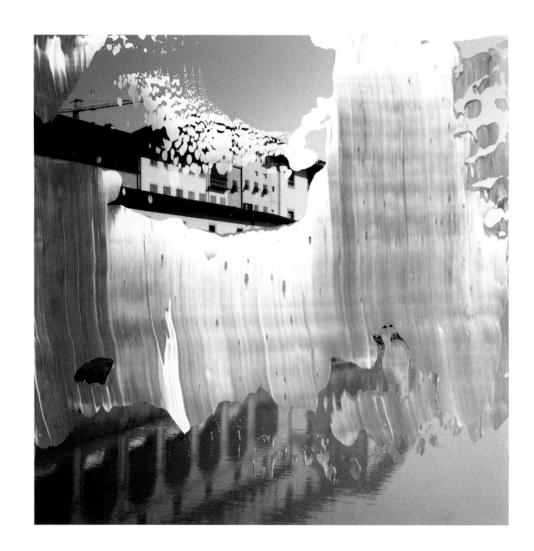

1. 2. 2000

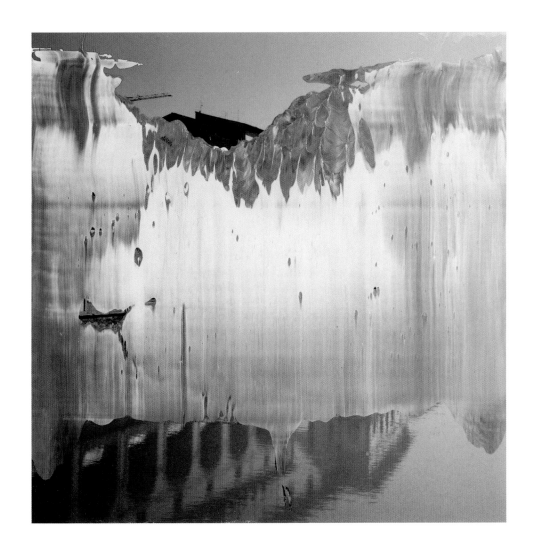

2. 2. 2000

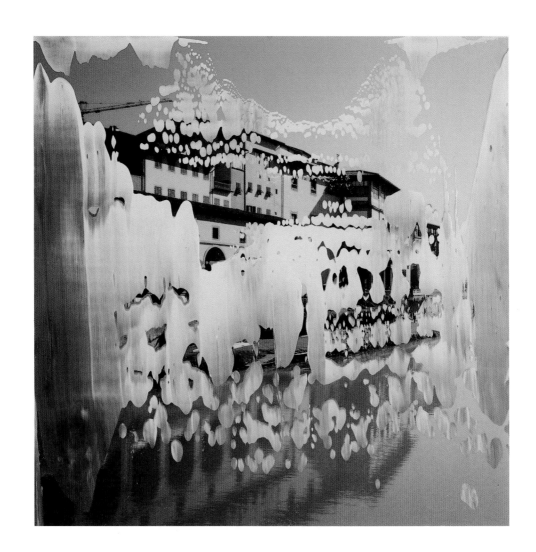

3. 2. 2000

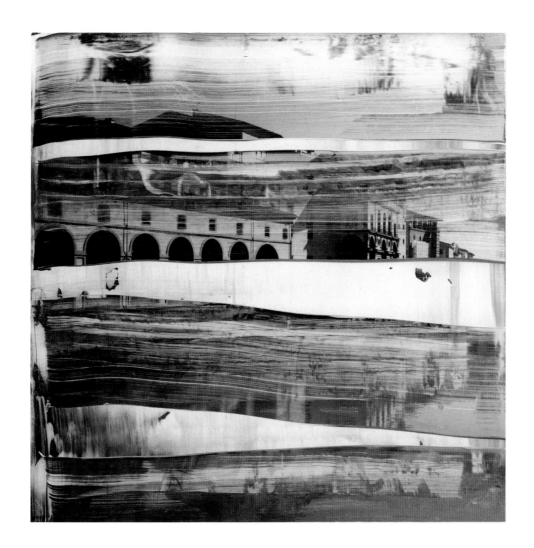

4. 2. 2000

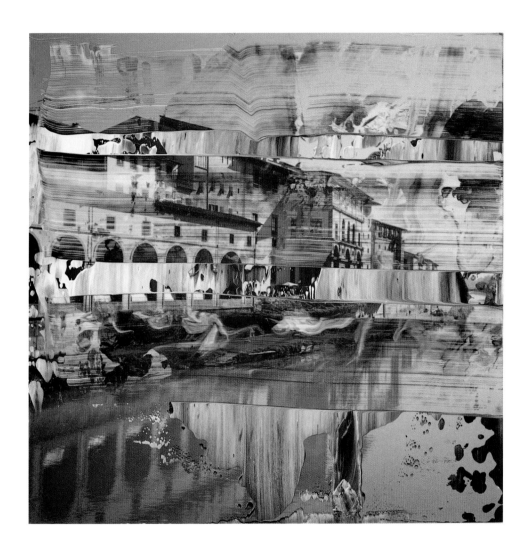

5. 2. 2000

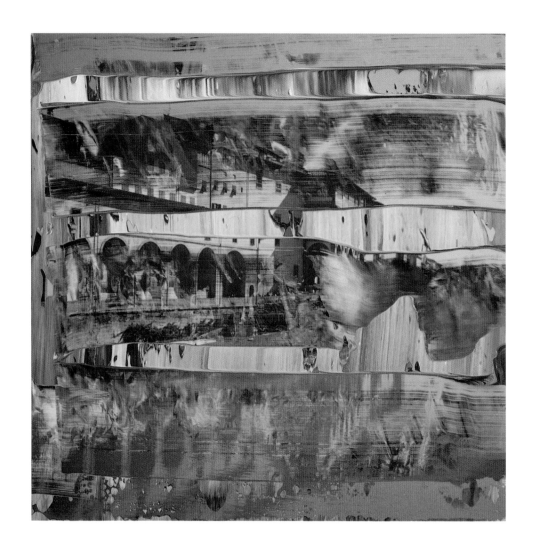

6. 2. 2000

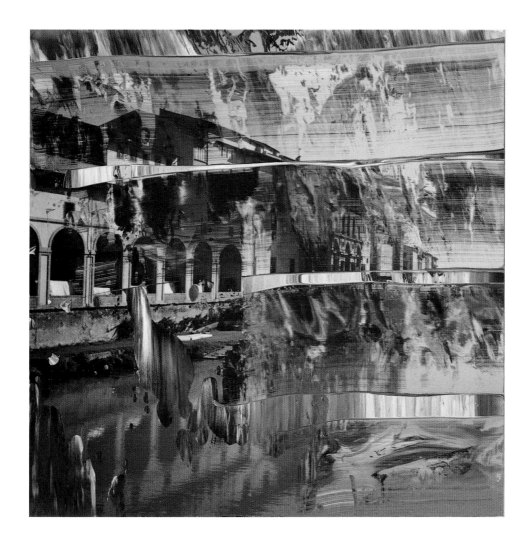

7. 2. 2000

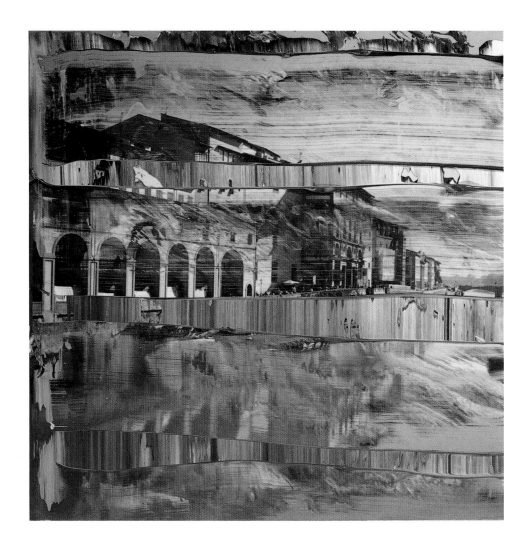

8. 2. 2000

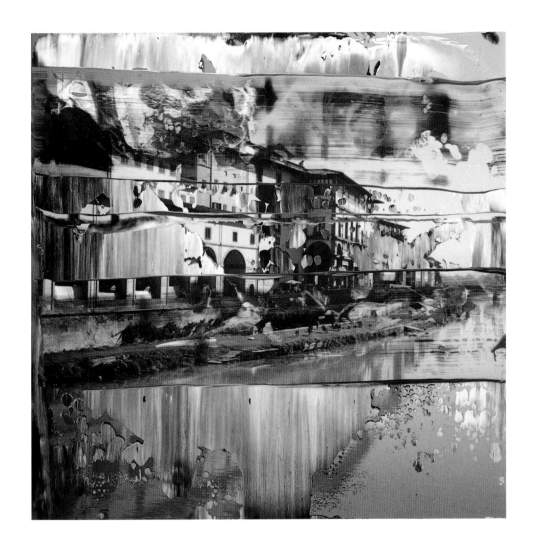

9. 2. 2000

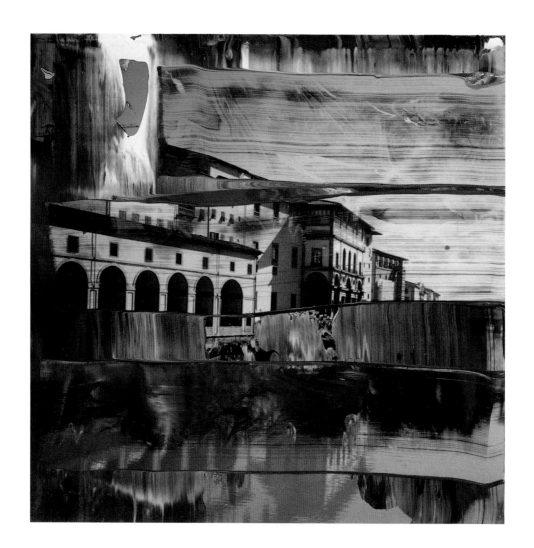

10. 2. 2000

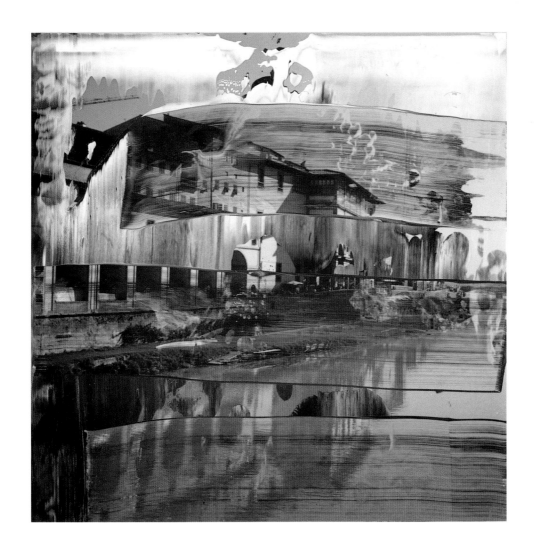

11. 2. 2000

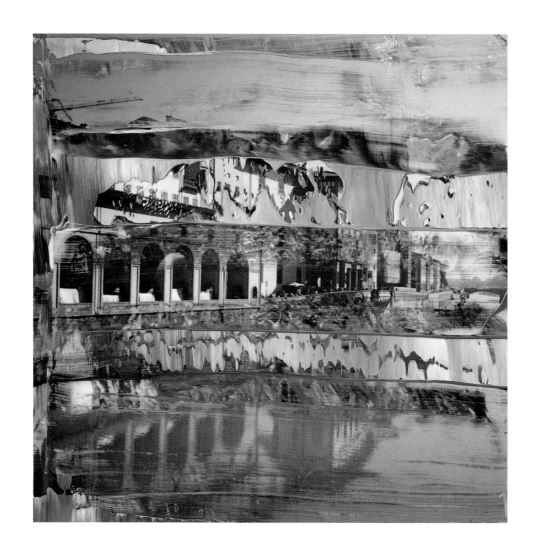

12. 2. 2000

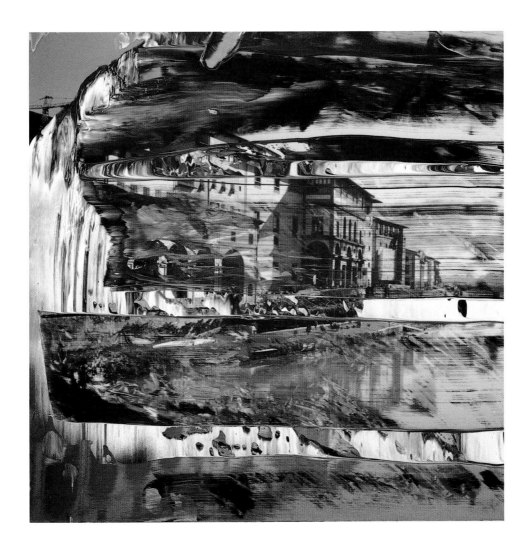

13. 2. 2000

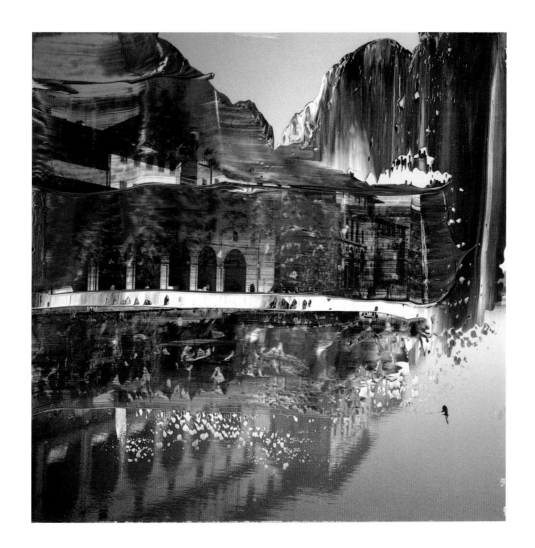

14. 2. 2000

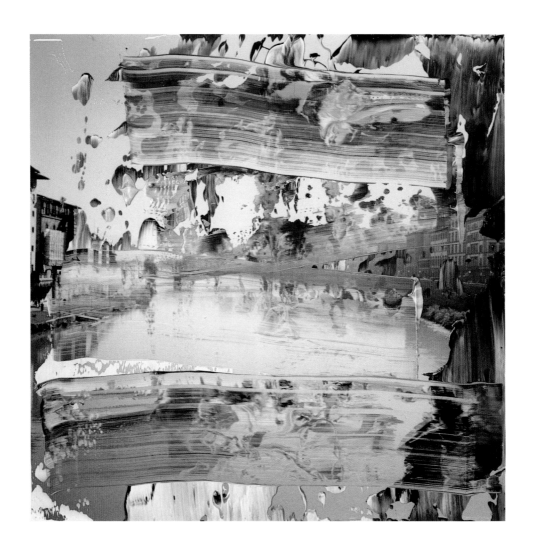

15. 2. 2000

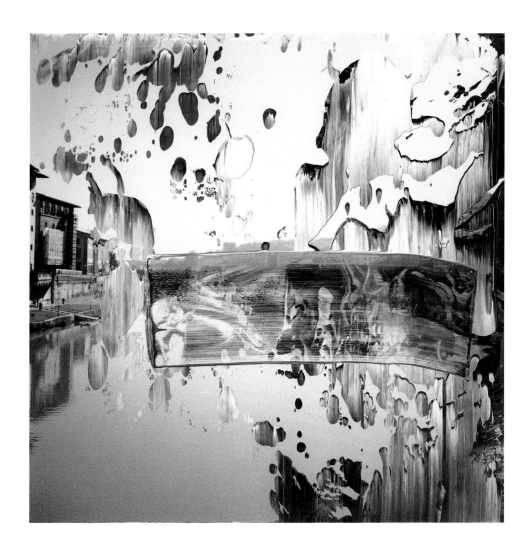

16. 2. 2000

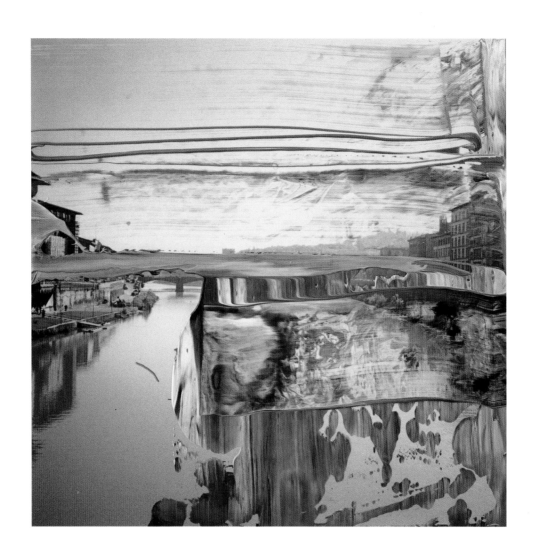

17. 2. 2000

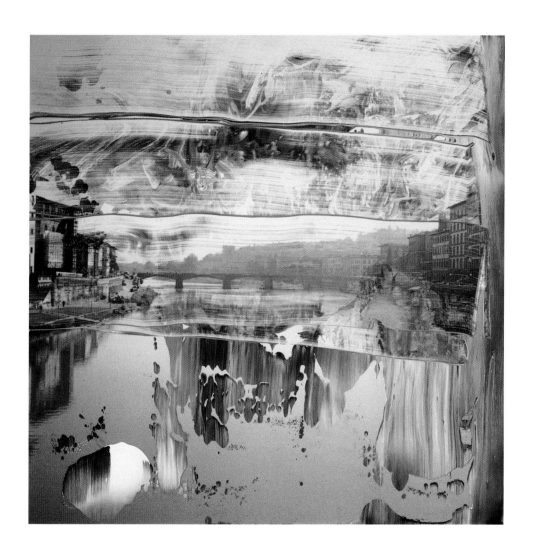

18. 2. 2000

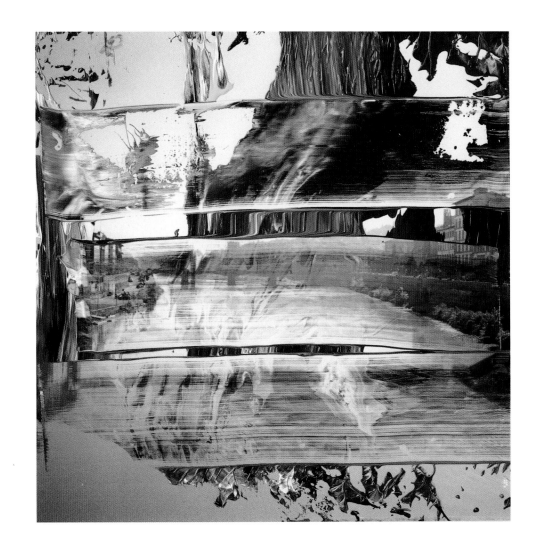

19. 2. 2000

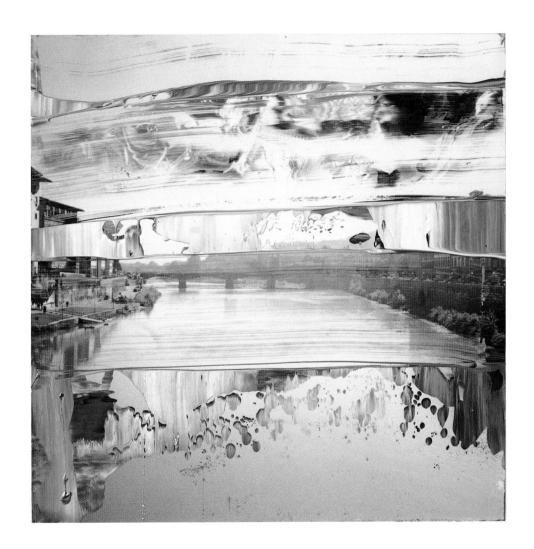

20. 2. 2000

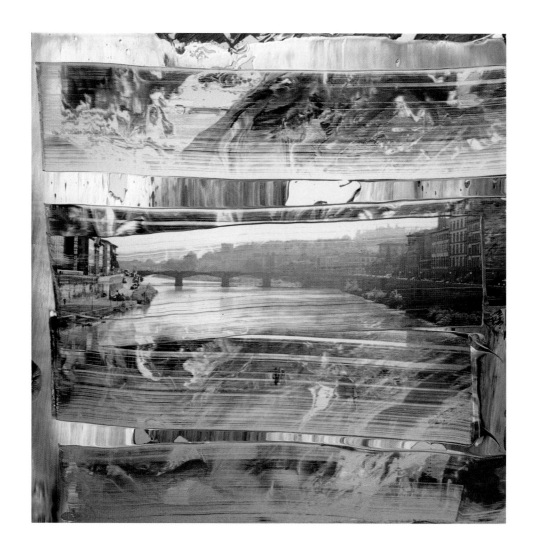

21. 2. 2000

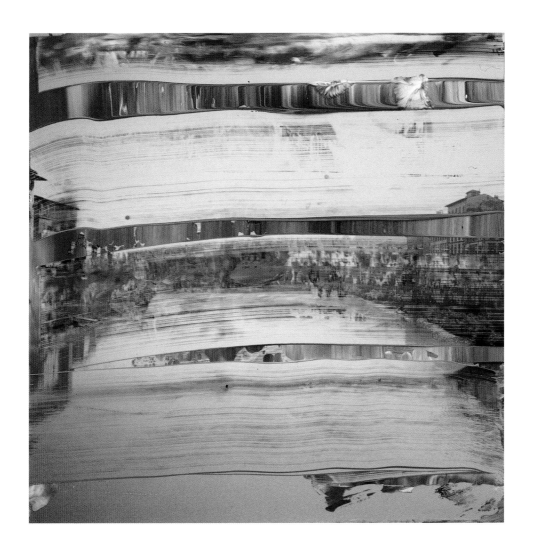

22. 2. 2000

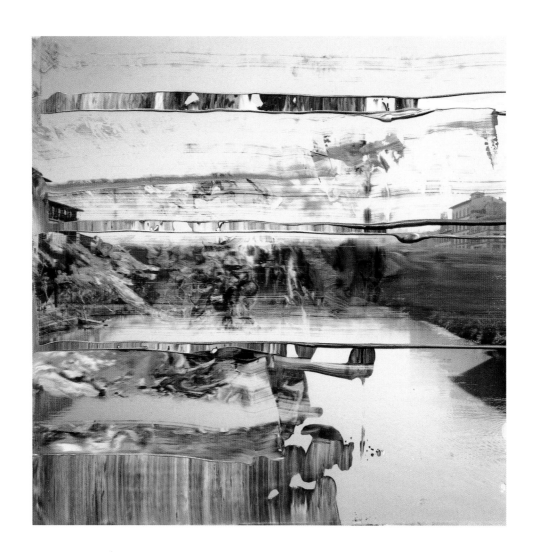

23. 2. 2000

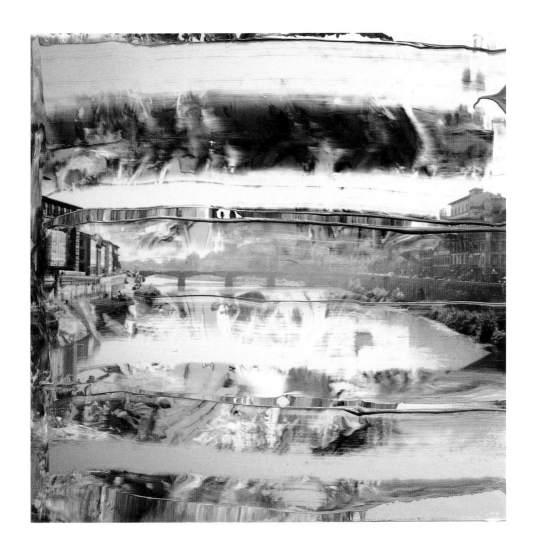

24. 2. 2000

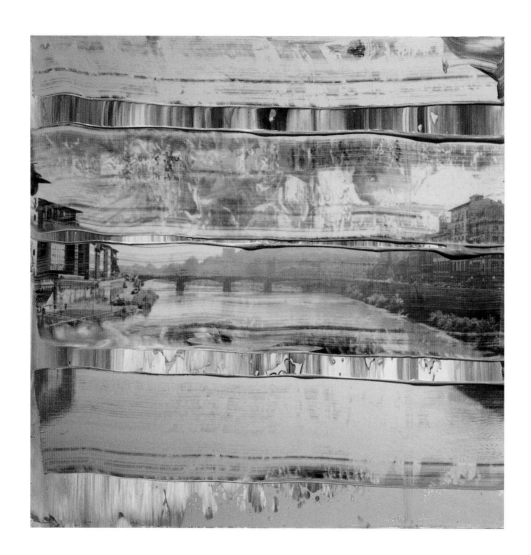

25. 2. 2000

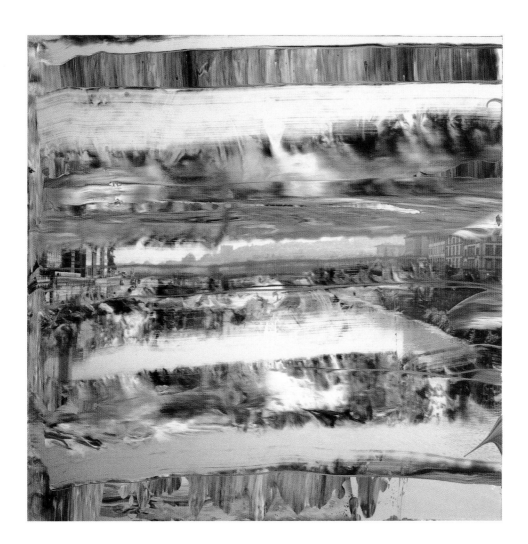

26. 2. 2000

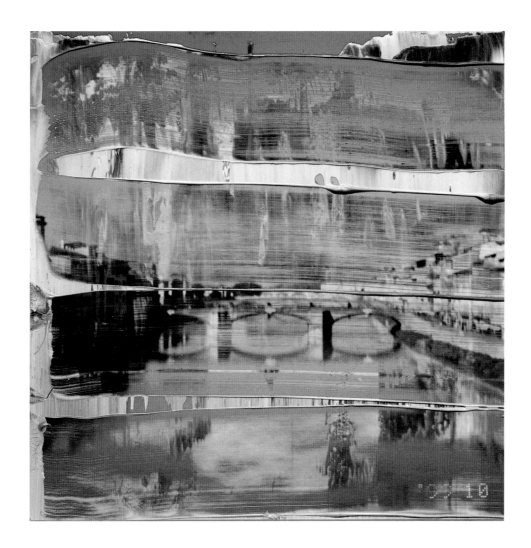

3. 3. 2000

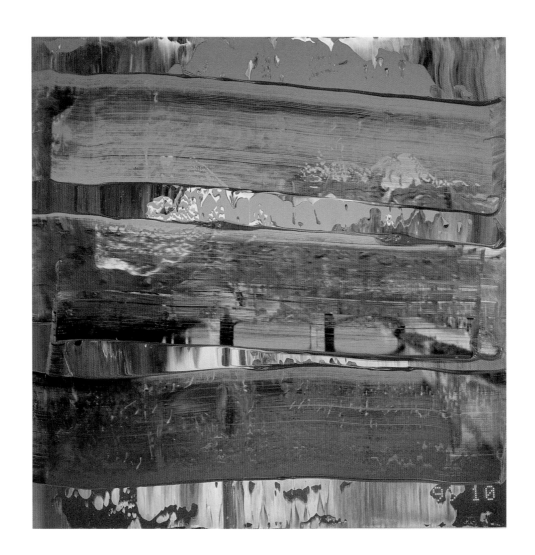

4. 3. 2000

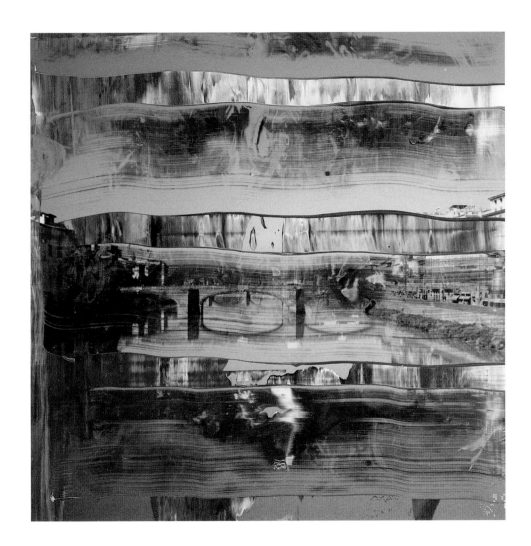

5. 3. 2000

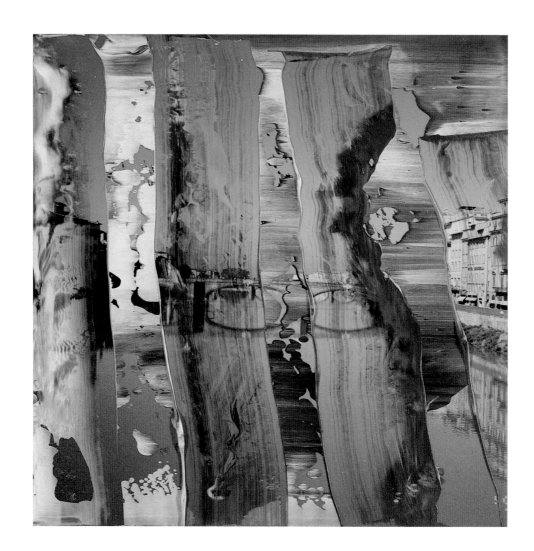

6. 3. 2000

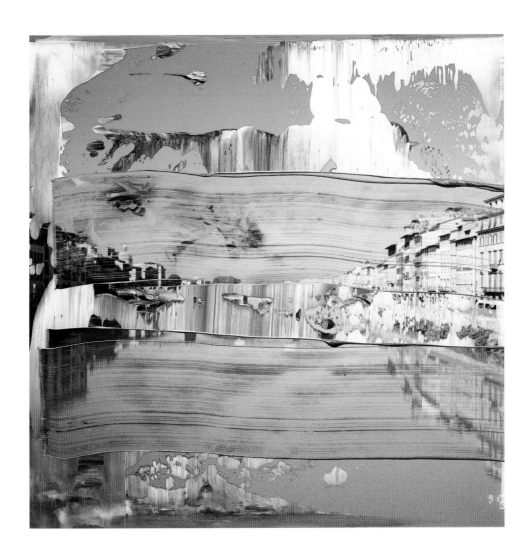

7. 3. 2000

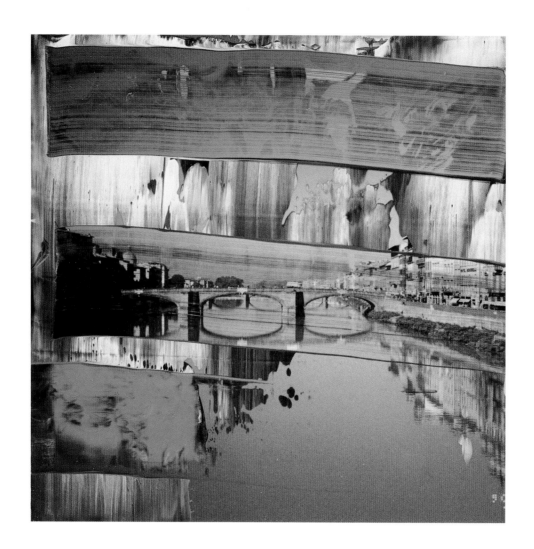

8. 3. 2000

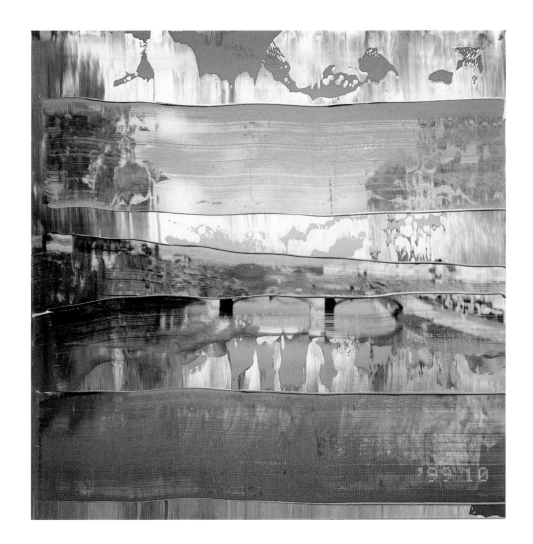

9. 3. 2000

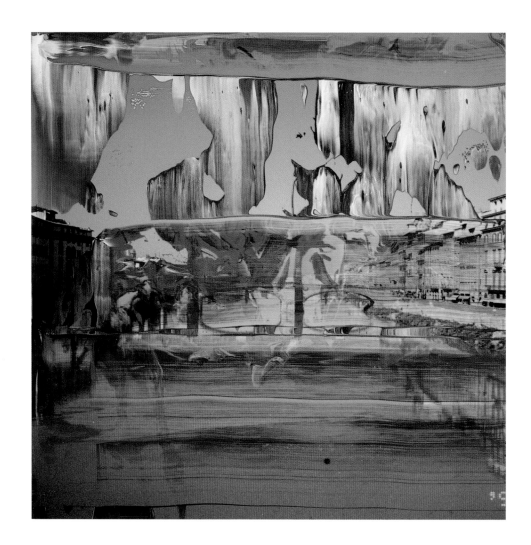

11. 3. 2000

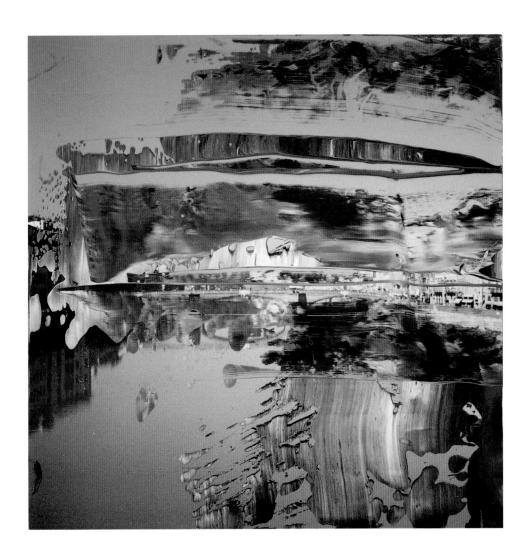

12. 3. 2000

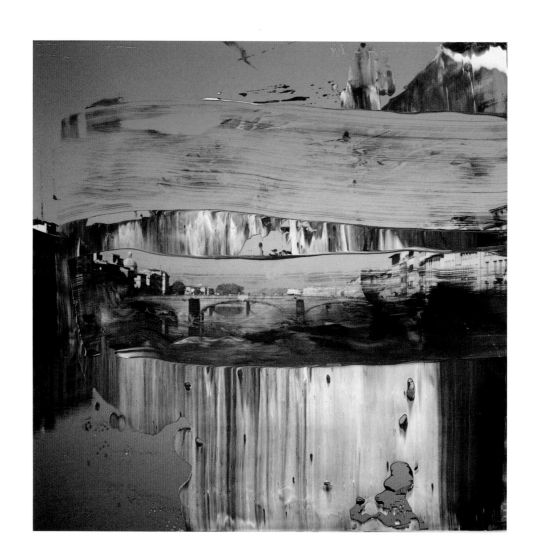

13. 3. 2000

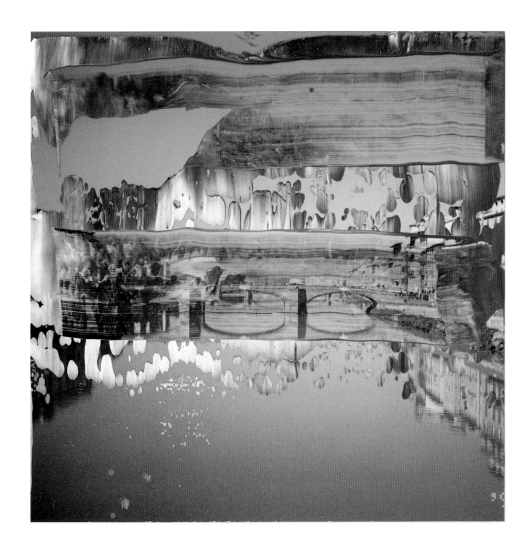

14. 3. 2000

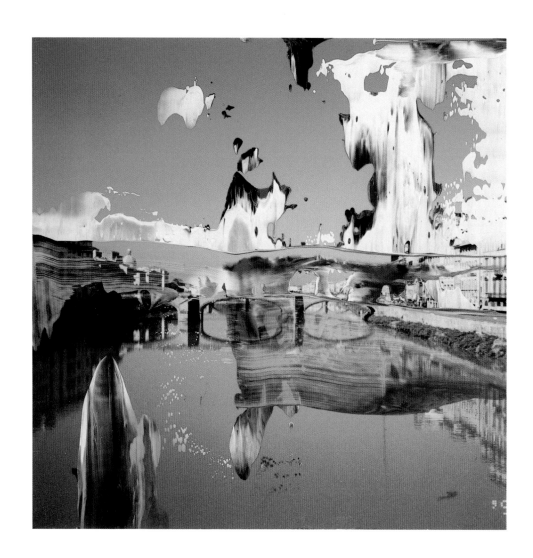

15. 3. 2000

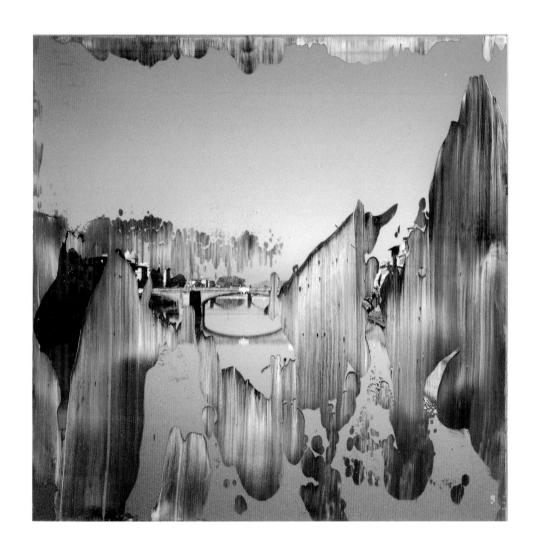

16. 3. 2000

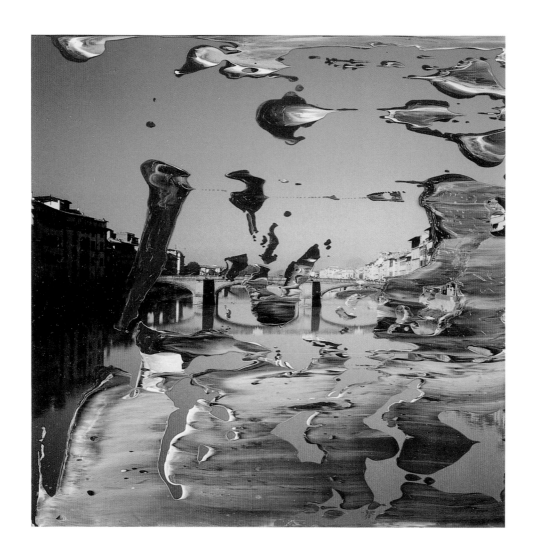

17. 3. 2000

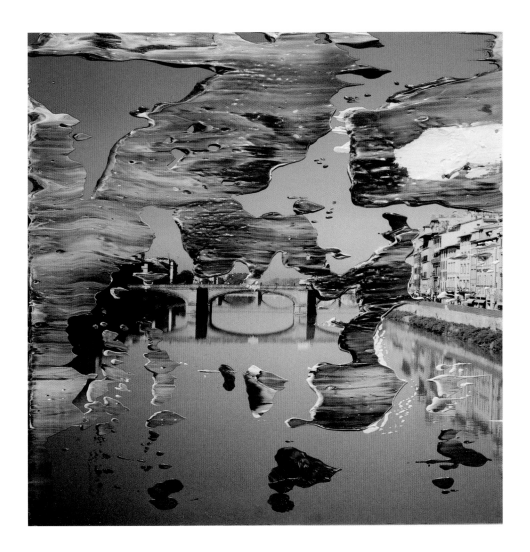

18. 3. 2000

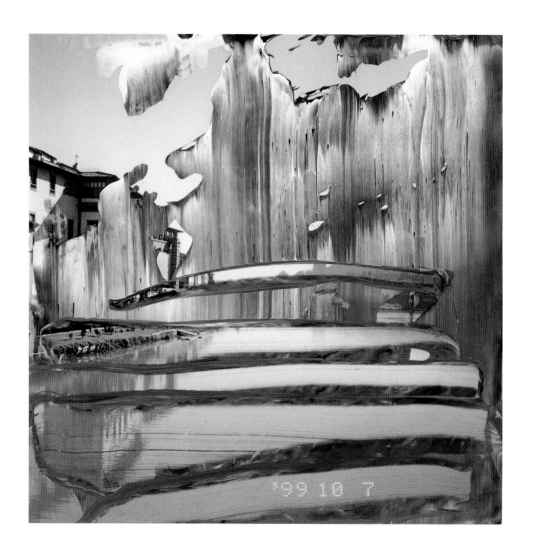

'99 10 7

20. 3. 2000

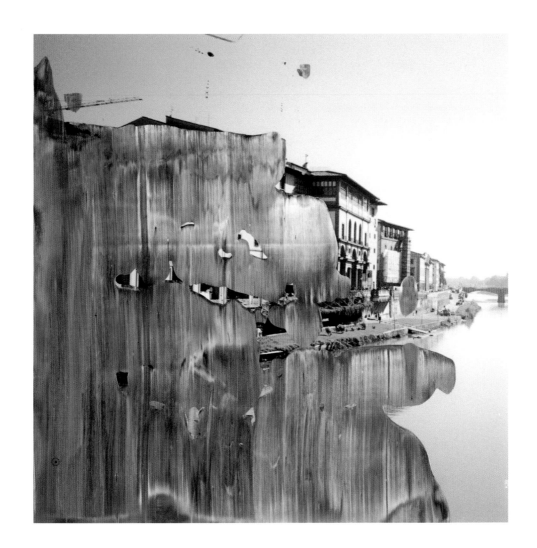

21. 3. 2000

Gerhard Richter produced his *Firenze* series in spring 2000. It consists of a total of 103 photographs that have been painted over by the artist. One hundred of those works are reproduced in this volume. Most of the works are views of Florence dating from October 1999, complemented by photographs taken in Cologne and interrupted by a single snapshot of the Leaning Tower of Pisa (*29. 1. 2000*). Richter has trimmed the originally rectangular prints down to a unified 12 x 12 centimetre square format. This format is that of a CD; the series was originally planned as an edition with accompanying music CD. *Firenze* covers the time period from *23. 11. 1999* to *21. 3. 2000*, although the artist has interrupted the continuous dating several times. Moreover, the dates indicate neither the day of the take, nor the day of the overpainting, but, as titles, simply serve to identify and catalogue the works. Their function corresponds therefore to that of the numbers of his paintings.

The series opens with a presentation of the group of travellers, the artist in the circle of his family and friends. This is followed—as a kind of intermezzo—by black-and-white photographs of abstract details of pictorial surfaces. Starting with the *1. 12. 1999*, the works show views from the artist's former studio on Bismarckstrasse in Cologne. On *21. 12. 1999* a new landscape can be seen. The remaining photographs were taken towards the end of that year in the woods round about his new studio on the periphery of Cologne. The following year, the scene shifts to Florence and different views of the cathedral and neighbouring Baptistry, as of *1. 1. 2000*. Various takes of the Arno, the bridges across the river and the buildings on its banks follow. Richter has included several prints of most of these views in the *Firenze* series.

Sometimes the photographs were taken so soon after each other that the spectator scarcely perceives the time difference (*21. 1. 2000* and *22. 1. 2000*).

For reproduction in this publication Gerhard Richter has chosen a format that is one centimetre larger than the original, a minimal intervention, much as in his graphic works *Hood* (1996) and *Erster Blick* (2000). Through this manipulation, which the reader scarcely notices, Richter creates a certain distance to the original, introducing a moment of alienation into the reproduction and thereby granting it a quality of its own. However, the reproduction can only aspire to this status here because Richter breaks with perceptual conventions and reverses the hierarchy between original and reduced reproduction.

Despite their modest formats, these overpainted photographs concentrate Gerhard Richter's main artistic concept: a sceptical questioning of our experiences of reality and an attempt to grasp that reality with the help of different painterly processes. The first painting listed in the register of works, *Tisch*, 1962, presents this problem of imitative depiction and abstract gesture as an equivalent juxtaposition of different painterly possibilities on one pictorial plane. Later, Gerhard Richter repeatedly reconnoitred this border area, questioning, among other things, the concept of reality in naturalistic landscapes by way of later, abstract overpaintings (numbers 606-2,3,4; 628-1; 628-3). These paintings were followed in 1989 by the first overpainted photographs, which Richter integrated into his work *Atlas* on two panels. Having gained some experience with this medium, he described the tense relationship between the different aspirations to reality of photography and painting in an inter-

view: "Photography has almost no reality, it is quasi just picture. And painting always has reality; the paint is tangible, has presence: but it always results in a picture ... I have taken small photographs which I then smeared with paint. This brought aspects of the problem together."

Gerhard Richter painted over the photographs by pulling the pictorial surfaces over the still damp paint on the wide rubber squeegees he had previously worked with on the large format paintings. The photographic representation gains in intensity through the overpainting and provides further perceptual possibilities for the spectator. The paint lies on the photograph like a foreign body and thus creates a kind of contradiction, distance, and hardness. Whereas here the overpainting counteracts the mood of the subject, in other examples it can also intensify that mood. Then, the illusionist depiction melds with the materiality of the paint to form a new indissoluble pictorial unit. However, the process of overpainting cannot be monitored and only partially predicted. For this reason, only the final judicious eye of the artist can decide on the work; Gerhard Richter has discarded many of the finished products and torn up the photographs.

The artist has modified his overpainting technique for the *Firenze* series and thereby brought it closer to his work on the paintings. He has gained more control over the process by using a practical paint knife to apply the paint to the photographic motif and then scrape it off again. Richter thus achieves here what is already guaranteed in his canvas paintings: a balance between structures arrived at by chance and deliberate graphic interventions and corrections.

When looking through the *Firenze* series the photographic motifs appear as individual artistic themes which undergo a variation through the overpainting. With each new subject, Richter also alters the tonal character and formal idiom of his painting. For example, he replies to the geometry of the window (*1.12.1999*; *17.–20.12.1999*) with a comparatively stringent colour application in horizontal and vertical bands, whereby his colouring takes up the autumnal splendour of the trees in the window frame. The tone and application of his overpainting on the following photograph of a snow-covered meadow and a bare forest (*21.12.1999*) are again correspondingly radical.

In his overpainted photographs Gerhard Richter confronts two opposing though not contradictory concepts of the experience of reality. The photograph shows the illusion of a naturalistic pictorial space, while the pastose paint itself possesses materiality, and thus reality, though it remains graphically abstract. Only by interlinking the two concepts of reality in the overpainted photographs does Richter succeed in making them not only question one another, but also mutually assume their respective qualities. "For me, there is no difference between a landscape and an abstract painting. In my view, the term 'realism' makes no sense." Gerhard Richter thus describes a fundamental principle of his artistic concept. In the photograph dated *7.1.2000*, the architecture and the passers-by seem to resist being recognisable by dissolving in the abstract structure of the paint. On the other hand, in the photograph *15.3.1999*, the painting—as an apparent cloud formation and water reflection— insinuates itself illusionistically into the photographed river landscape.

When Gerhard Richter repeatedly interrupts his work on the *Abstrakte Bilder*, as he has been doing since 1976, to paint romanticising landscapes, he is giving naturalistic representation equal status alongside the kind of painterly reconstruction of reality he is striving for in the *Abstrakte Bilder*. The overpainted photographs bring the two possibilities together, presenting them as related, but above all as complementary interpretative approaches in an artistic appropriation of reality.

Dietmar Elger

Imprint

Edited by Dietmar Elger

Concept Gerhard Richter

Editing Dietmar Elger
Translation Pauline Cumbers
Graphic design Christine Müller
Reproduction Schwabenrepro, Stuttgart
Printed by Dr. Cantz'sche Druckerei, Ostfildern-Ruit

Published by Hatje Cantz Verlag
Senefelderstraße 12, 73760 Ostfildern-Ruit, Germany
Tel.: +49/711/4405 0, Fax: +49/711/4405 220
Internet: www.hatjecantz.de

Distribution in the US D.A.P., Distributed Art Publishers, Inc.
155 Avenue of the Americas, Second Floor, USA-New York, N.Y. 10013-1507
Phone 212 6 27 19 99, Fax 212 6 27 94 84

ISBN 3-7757-1059-0

A German edition of this volume is also available.
ISBN 3-7757-1058-2

Printed in Germany

PHOTO CREDITS

Friedrich Rosenstiel, Courtesy Atelier Gerhard Richter, Cologne
23. 11., 28. 11., 29. 11., 30. 11., 18. 12., 19. 12., 21. 12., 23. 12., 27. 12. 1999
2. 1., 3. 1., 6. 1., 10. 1., 18. 1., 19. 1., 29. 1., 5. 2., 6. 2., 7. 2., 8. 2., 9. 2., 10. 2., 11. 2., 12. 2.,
13. 2., 14. 2., 15. 2., 16. 2., 17. 2., 18. 2., 19. 2., 20. 2., 21. 2., 22. 2., 8. 3., 20. 3. 2000

Courtesy Nolan/Eckman Gallery, New York 1. 12. 1999, 26. 2. 2000

Courtesy Marian Goodman Gallery, New York
2. 12., 3. 12., 5. 12., 10. 12., 12. 12., 13. 12., 20. 12. 1999
23. 2., 24. 2., 25. 2., 3. 3., 7. 3., 9. 3., 18. 3. 2000

Courtesy Anthony d'Offay Gallery, London
6. 12., 7. 12., 8. 12., 9. 12., 14. 12., 15. 12., 16. 12., 17. 12. 1999
21. 1., 22. 1., 23. 1., 24. 1., 25. 1., 26. 1., 27. 1., 28. 1., 1. 2., 2. 2., 3. 2., 21. 3. 2000

Courtesy Galerie Fred Jahn, Munich
24. 12., 25. 12., 26. 12., 28. 12. 1999
4. 1., 5. 1., 7. 1., 8. 1., 9. 1., 11. 1., 12. 1., 13. 1., 14. 1.,
15. 1., 16. 1., 17. 1., 11. 3., 12. 3., 13. 3., 14. 3. 2000

Courtesy Private collection, Bad Kissingen 1. 1. 2000

Achim Kukulies, Düsseldorf; Courtesy Galerie 20. 21, Essen 4. 2. 2000

Prudence Cuming Associates Ltd.; Courtesy Private collection, London 4. 3. 2000

Jean-Pièrre Kuhn, Zurich 5. 3., 6. 3. 2000

Michael Herling, Hanover 15. 3. 2000

Courtesy Private collection, Baden 16. 3. 2000

Courtesy Wako Works of Art, Tokyo 17. 3. 2000